Architectural Painting
1991, oil on linen
96 x 72 inches

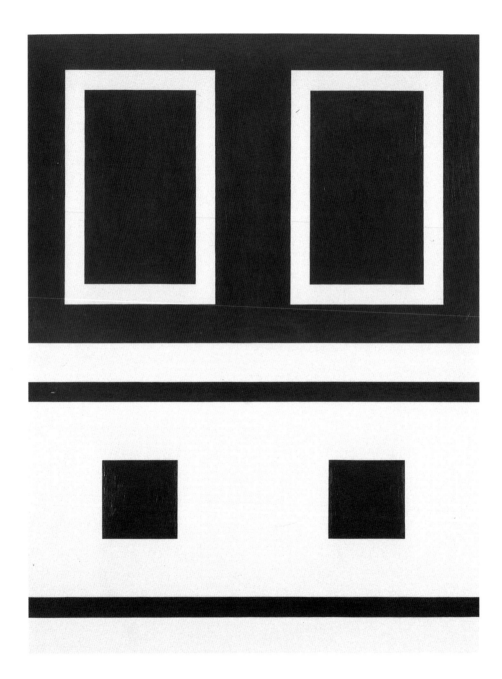

Andrew Spence

Interview by **Colin Thomson** Essay by **Richard Armstrong** Edited by **William S. Bartman**

A·R·T·PRESS

Andrew Spence in his studio

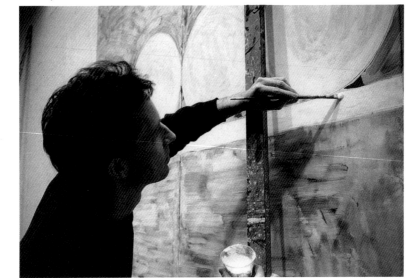

Design:
Lausten/Cossutta Design

Copy editing:
Miyoshi Barosh

Printer:
Typecraft, Inc.

Distributor:
Distributed Art Publishers
636 Broadway, Room 1208
New York, New York 10012
800 338-2665
212 673-2887 fax

Photos:
Dennis Cowley, page 2, 36
Eric Baum, pages 42-44
Brian Forrest, page 38
Grant Taylor, pages 14, 15, 20-22
Frank Thomas, pages 10, 11
Ron White, page 29
Zindman/Fremont, pages 17, 28, 30,
32, 34, 35, 39, 40

Other titles published by
A.R.T. Press include:
Kim Abeles, Vija Celmins, Jimmy
DeSana, Judy Fiskin, Mike Kelley,
Anne Scott Plummer, David Reed
and Pat Sparkuhl.

ISBN 0-923183-07-8

Andrew Spence interviewed by **Colin Thomson**

Colin: *I have known your work for about twelve years, since we first met out in Los Angeles. I think it is interesting that the work that you were doing then and the new work have a lot of parallels. A lot of the intentions in that earlier work are also in what's happening now. Would you speak a little bit about what you were doing when you first became an abstract painter? What you thought was going on in your paintings?*

Andrew: By the time you and I had met in 1977, I was constructing molded modular paintings based on loosely formed ideas about prefabrication and Southern California architecture. Prefabrication was significant to me for being such a major part of the Southern California landscape—meaning tract homes and industrial parks. This is a theme that goes back to 1969 when I first met Esther McCoy, an architectural historian with whom I studied and later befriended in Los Angeles. So that's how I became aware of architecture and wanted to somehow involve it in my work.

Colin: *Didn't she do a big show on Schindler and a book about California architects?*

Andrew: I don't know about a show on Schindler but she did work in his office back in the thirties. She worked on a design show at the Whitney and a show about the Case Study House program at the Museum of Contemporary Art in Los Angeles. She has also written several books on Southern California architects and was one of the authorities on the subject before she died.

Colin: *Did you have any idea at the time that you might be interested in being an architect?*

Andrew: Not at that point. But earlier on, when I was first starting out in college, I thought I might become an architect or designer. Eventually those aspirations faded away as my interest in painting got stronger.

Colin Thomson
Popeye
1990, oil on canvas
54 x 46 inches

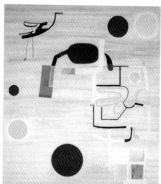

Untitled
1971, enamel on wood shingles
16 x 120 inches

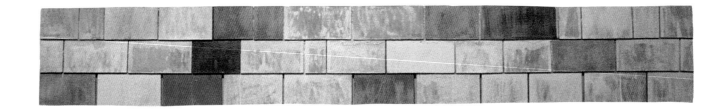

Untitled,
1972, stained canvas
and wood
60 x 216 inches

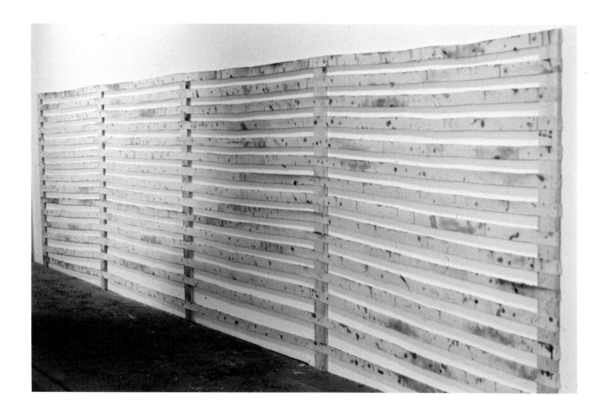

Colin: *During that period, which California painters were you familiar with? Who were you looking at?*

Andrew: In 1971 I took a job at an art warehouse and met some painters who were still getting established and were also working there. Eventually we took an interest in each other's work. We would go to artists' studios to pick up or deliver artwork and had a chance to see not only what they were working on but *how* they were working as well. You'd peer in and see what people were doing. It was interesting but no one was really making images. They were making process art and they were making conceptual art. A lot of people were doing sculpture that hung on the wall. The most established painters were making very decorative paintings—lots of patterns and bright colors. Everybody, including myself, seemed to find a way not to make a painting using an image. By 1974 I knew most of the Southern California artists through that job and Nick Wilder, who was an art dealer at the time.

Nick's storage at the warehouse was one of the most interesting to me and contained several of John McLaughlin's paintings. These paintings caught my attention while I was working on an inventory. They were so different from what was generally around—very minimal, geometric, and calm. The tension from the calm was weird. It took me a long time to figure out what in particular attracted me to McLaughlin's work. I finally did come to an understanding about this attraction and it's been a measure for me ever since.

Charles Eames's designs had the same effect on me as John McLaughlin's paintings. I saw a show of his work at the art gallery of the University of California, Los Angeles. Actually, I had to pick them up and deliver them to his office.

Colin: *You didn't actually know these people, so you were sort of developing in Los Angeles as a painter in a rather cloistered environment. Is that incorrect to say?*

South Los Angeles, 1975

Andrew: I didn't live in a neighborhood full of artists. Most artists lived near the beach in Venice. Not being from California and not having gone to a Los Angeles art school, I always felt that I was peripheral to the local scene. When I wanted to see more work than I saw at my job I would go to galleries. I didn't socialize with artists other than the ones that I worked with. I never worked the art circuit as some did.

Colin: *Then you became involved with Nick Wilder.*

Andrew: Yes. Nick would visit his storage in the warehouse quite often. We became friends and every few months he would stop by my studio for a visit. In 1974 he invited me to show with him. I made a body of work that consisted of about ten paintings of acrylic Rhoplex on canvas. Every painting was just like the next painting except that they were of different colors and sizes. One half of the canvas was one color and the other was another color, but very close in value. I was trying to create an interesting looking surface—like a detail of a section of a building. The surface was supposed to be the image. It took a while to realize that the paintings in this show looked great as an installation but on their own there wasn't enough to see and they didn't hold up.

One time someone who was unfamiliar with contemporary art, but knew I was an artist, stopped by for a visit at my studio. He commented on being interested in seeing my work sometime as he stood right in front of one of my paintings. While looking at the painting, he asked what it was for. Embarrassed, I replied that I used them for sound baffling. From that moment I wanted my work to be more communicative to people. I started looking around my environment for less abstract references than the surface of a wall and became interested in the colors used for automobiles, recreational vehicles, and other industrial purposes. I liked the way recreational vehicles were painted: a white ground with top and bottom accent-color stripes. The surfaces were usually made of aluminum

Santa Barbara, 1975

Untitled
1975, Rhoplex on
canvas [8 parts]
80 x 120 inches

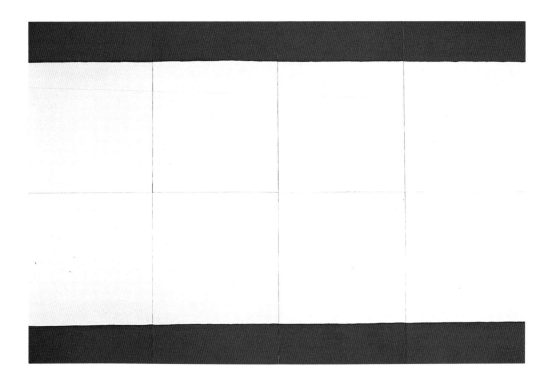

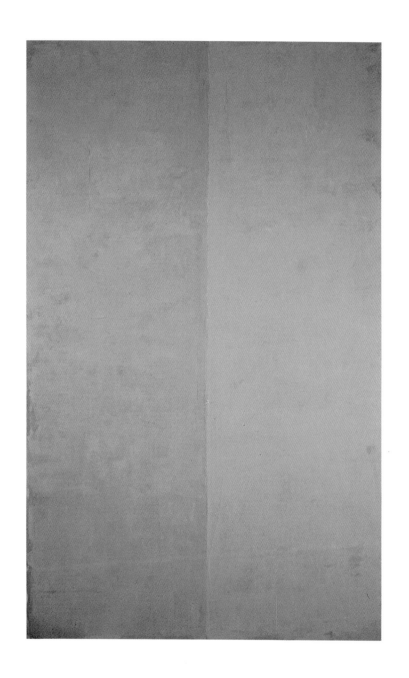

Untitled
1974, Rhoplex on canvas
104 x 64 inches

stamped to look like wood grain, which amused me. My wife, Sique, and I would go through trailer parks taking snap shots. We even went to a mobile home factory and saw how they were made.

Colin: You really made a conscious decision that you would find a more interesting subject matter, and that you would find it not in your studio but by going out.

Andrew: Yes, I wanted my work to be reflective of my environment and my place in time. Pop art was important for that, at least it was for me, as was all painting before photography was invented. Before photography, painting was the only visual recording of history. I wanted an abstract format to function in the same way and to communicate my point of view about my surroundings to people.

People started responding to the work better. They weren't so much aware of it looking like the side of a trailer, but there was some kind of association being made. That was an interesting observation: There was the beginning of some kind of response.

Colin: So after these earlier paintings you started constructing a surface on the painting that would actually lump out along ridges.

Andrew: Just before I left for New York in 1977, these earlier paintings led to molding bas-relief surfaces made out of acrylic Rhoplex mounted like a painting on either plywood or canvas. I would paint on these surfaces as if they were sectional pieces of a larger whole, such as a building façade or the side of a trailer. The effect was similar to an imprint.

Colin: But this two-step system of working would also serve as a distancing effect between what the painting would look like and how you were working on the painting. So it wasn't suddenly all in your hands.

Santa Barbara, 1975

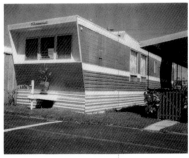
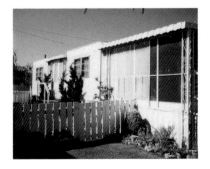

Andrew: I was still experimenting on how and what to paint on these new surfaces and tended to keep the painting very simple. The paint jobs on trucks, trailers, recreational vehicles, and cars were used as references for the painting part of this process.

Colin: *When you came to New York and these references seemed less relevant to you, where did you go for your subject matter?*

Andrew: That's when I started drawing images using geometric shapes as opposed to the façades and bas-reliefs that I was doing in L.A. I realized very quickly that West Coast references didn't make sense in New York because everything in New York is a hundred years old and made out of brick. Prefabrication wasn't as relevant here. I began to have difficulty focusing on new source material. In a way, maybe there was too much information. I had to just start over so I went back to the drawing board.

I don't know why I wanted to do the geometry, but I think that, again, it comes out of architecture. Also it's better organized and I need to be organized. It seems to have something to do with that.

I was drawing a lot of rectangles and squares and circles and other geometric shapes. I selected the lasting ones for painting ideas. This way of working was very random and had its problems. Every time I got something that I liked, I had to go run through my reference books just to see if I'd seen it someplace; or whether someone had already done this; or ask myself why do I like this; or why does this look so familiar. This approach to painting was very unsettling.

So I started looking at things that I admired for their design qualities and abstracting them into images for paintings. This helped me narrow down the range of possibilities to forms that had personal significance. The paintings that resulted from this approach were immensely satisfying. I realized that if I wanted to get to an original form I had to dig deeper inside of myself.

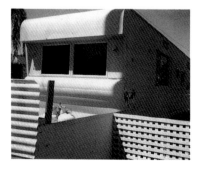

Untitled
1977, enamel and Rhoplex
on canvas
26 x 26 inches

Untitled
1977, Rhoplex on canvas
42 x 42 inches

I also began realizing that the more eccentric my work became the less it looked like other people's work. That was kind of a refreshing thought, so I would try to find eccentricity within myself. For one painting, I interpreted the experience of seeing a raft floating on a lake through some trees as a geometric, abstract image. This approach took the emphasis off the random search for subject matter and allowed me to concentrate on the painting process.

Colin: *Almost as if working from a narrative.*

Andrew: Sometimes, yes.

Colin: *At least a soliloquy to yourself.*

Andrew: Yes, but it wasn't easy and it took a long time to get that thing going.

Colin: *When people are looking at your paintings how do you feel about them tying into your original thought? For instance, the painting* Swivel Chairs *has as its subject Eames chairs, do you feel that recognizing the Eames chairs might co-opt people from seeing beyond the image of chairs?*

Andrew: I do wonder what people actually see. When I'm painting I'm also the viewer. I see the abstraction—that is what's important to me. I hope other people see that too.

Recently, I made a painting using a gate as a source. It worked well as an abstraction, but the gate was still recognizable to some while others saw it as a ping-pong table.

I think that people who *want* to see beyond recognition of the subject matter will do so. As for the titles, they are just names so we know which painting is being referred to when we talk about it.

Saranac Lake, New York, 1987

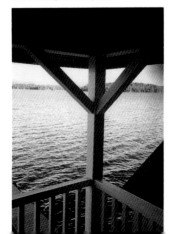

Eames armchairs

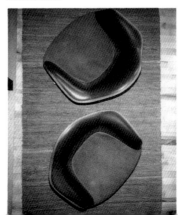

Swivel Chairs
1986, oil on linen
mounted on wood
84 x 60 inches

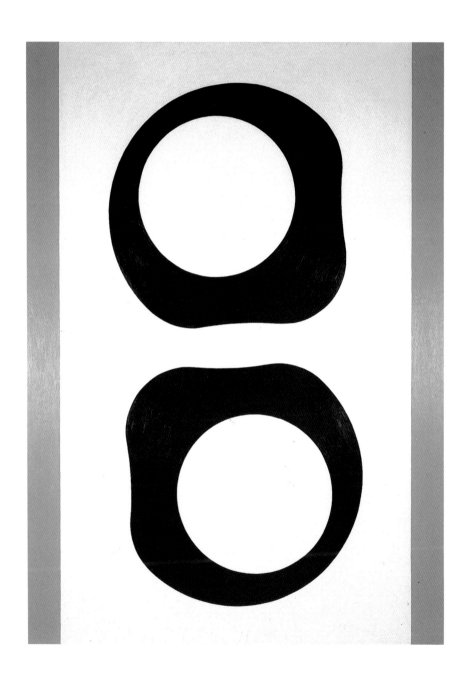

Colin: *Do you feel that some of the paintings are paintings and others are objects?*

Andrew: My early paintings from California are about looking like objects, both in the sense of their shapes and in the way they are painted. Do you remember when all cars seemed to be two-tone? And now they are all one color. It is interesting to think about this--was it just the fashion or did it have something to do with the economy, cutting costs by eliminating a color? Or is it a change in taste, in ideas about what looks modern? I was interested in these design decisions and the way they affected people.

The New York paintings are much more pictorial. The images are abstracted from everyday objects that are interesting to me because they have an intended purpose for existing which is connected to the way they look. It's the shape that's invented. You can look at that Sony cassette recorder you're using for this interview and wonder why the buttons are where they are or wonder whether there is a better arrangement. Or whether it's a good idea to have the microphone positioned on the corner. Everything has a purpose which helps to define its shape: form follows function.

Colin: *Everything is a sculpture.*

Andrew: Why is a chair so many inches off the floor? Why is a steering wheel placed where it is in a car? There is a reason for everything in design and architecture. The Museum of Modern Art's design collection includes a leg splint that Eames made for the army or navy during World War II. I used to have one hanging on my wall—it was a beautiful object and really comfortable, too.

I've been collecting old fishing lures which also have something to do with my art. They are the epitome of things man-made. These lures are supposedly designed to catch fish but they are really designed for people to buy, the fish aren't buying them. They are very seductive and extremely elegant; the shapes and colors are quite extraordinary.

Eames leg splint

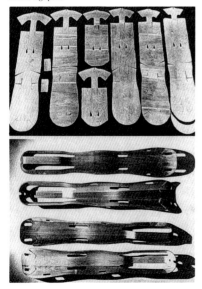

I discovered, by reading and doing this kind of work, that certain colors are more attractive to people than others. Attraction to a particular color doesn't seem to happen on a universal level but seems to be determined by geography—it varies from city to city.

Colin: *Are there any colors that you are not attracted to?*

Andrew: No.

Colin: *Do the paintings usually start from an idea such as "here is what the image will be," or do you just have a feeling that you need to do, for instance, a black painting now?*

Andrew: I'll use either approach to make a painting. If the image comes first then the color will come later, or if a color comes first then the image comes later. I'm flexible about possible changes but I have to have something in order to get started.

Colin: *Is there ever a situation where there is no idea, no new painting coming out?*

Andrew: Yes, it is very frustrating and seems to happen at some point every year. I still go to my studio to draw and work on other projects. I keep sketches and notes, that go back over the years, that pertain to completed paintings and paintings that were never made. Sometimes I can find something there. I think ideas are everywhere but you have to be in the right frame of mind to see them.

Colin: *How many variations are there from the original idea before you make the actual painting?*

Andrew: I do as many variations of an idea as is necessary to determine whether or not I want to proceed to the painting stage. This could take anywhere

Rosarito Beach, Mexico, 1975

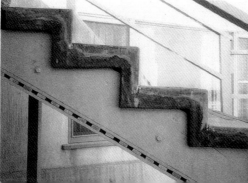

110
1980, oil on canvas
108 x 72 inches

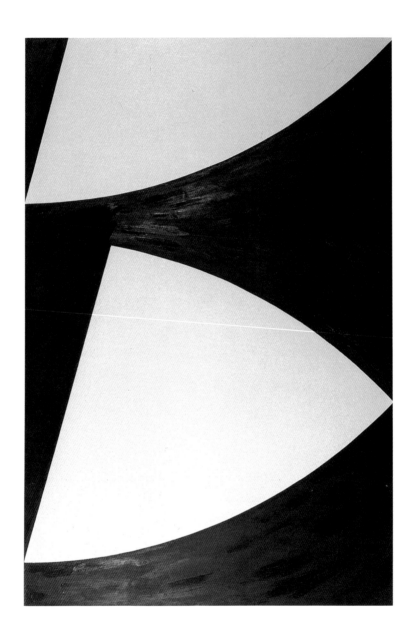

105
1980, oil on canvas
48 x 54 inches

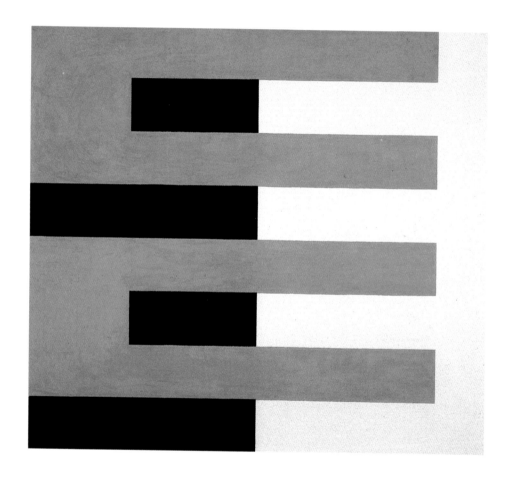

83.5 [Coffee Table]
1983, oil on canvas
60 1/4 x 48 1/4 inches

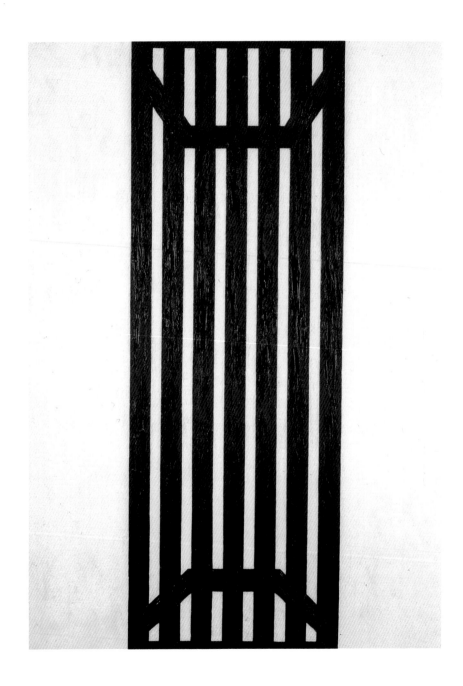

from a day to a few weeks. These variations on an idea are worked out in small drawings on a sketch pad that function as visual notes--drawings that try to clarify ideas by developing colors and shapes. Trying to invent a shape is a hard thing for me to do, and it often takes a long time to decide whether or not I like something. I try to sketch out as many possibilities on a shape as I can think of to know which one is most right. I also try to limit my options to certain criteria which use visual rather than verbal language; I can't really explain the criteria because it's too elusive.

If you were to look through one of my sketch pads, you would see several pages filled with variations of the same drawing. You would also see an idea or image among many other ideas that crept in and began to develop on a page. Then, on the next page, there may be two or three more variations of the first image, and some other ideas. There are times when I exhaust all the possibilities before realizing that it is not going to work out as a painting. At that point, I move on to something else.

Colin: *So by the time you start working on a painting you're fairly clear about what you're doing?*

Andrew: Yes, but that changes as the painting develops. Hopefully, at a certain point, a painting will begin to tell me what to do as it takes on a life of its own. The original idea may become less important and the changes that take place might even obliterate it. One of my paintings started out as an image of the picture window in my studio. The drawings were way too literal even though they were only grid patterns. I kept increasing the thickness of the lines making the grid appear fatter until it became more of a shape and less gridlike. The image got better and became resolved after superimposing some rectangular shapes for balance. By this time, the idea had nothing to do with the picture window and looked more like a section of a building façade. I used green paint for vegetation and named the painting *Ivy Windows.*

Nelson bench

The studio, New York, 1991

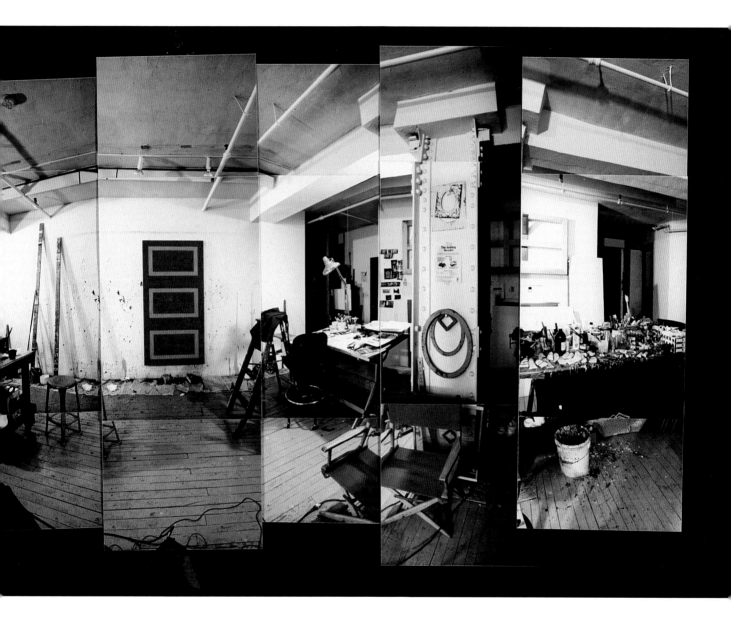

The progression from one painting to the next is very important to me. I have to make the first painting in order to figure out what the next painting is going to be. There actually is a relationship between paintings, although perhaps it may not be about the object, but on a visual level there is this progression. There is a rhythm that I like to establish that leads to future paintings.

Colin: *Could this rhythm be a color progression?*

Andrew: Not exactly, I think it's an intuitive progression in which color is a factor in the same way that scale or subject matter might be a factor in determining the movement from painting to painting.

I try to work on three or four paintings at a time in different stages of development. If the rhythm established by this way of working is interrupted by one of the paintings not going as planned, then I would prefer to stop working on everything and concentrate on the problem at hand.

Colin: *It's funny because you work on a flat surface and deal with associative images but you're also dealing with the history of abstract painting. There is a lot of humor that happens in the juxtaposition of all of those different elements. You're playing with more than a full deck of cards, in some ways, because as you're working on the paintings sometimes ideas will become apparent that you didn't even know were there.*

Andrew: I like using formal elements in my work. I'm not sure, however, if this formalism comes out of art history or is just something that already exists in the nature of the man-made objects which are my subject matter. The tongue-in-cheek aspects which may occur in my work are amusing but it is not intended to be the main focus, just one of the elements involved. That painting over there in

Knoll drafting stool

Old Town canoe

the corner is called *Hanging Table*. It's about a folding table that hangs on the wall when not being used, like a painting or a Shaker chair. That may be amusing, but as an abstract painting, *Hanging Table* is dealing with serious formal issues which are important to me.

Colin: *Looking back at your résumé, and out of a personal curiosity, how did you get from Bryn Mawr to Norman, Oklahoma?*

Andrew: I applied and was accepted at the University of Oklahoma in Norman. After high school, I decided to radically change my environment and experience another part of the country. I had some friends that were already there and liked it. I studied art there and the art department was good. There was also an interesting architecture department that was located at one end of the interior of the football stadium. You would have thought that it would have been located in some kind of modern building, but it was one of the more architecturally interesting buildings on campus. Another part of the campus still consisted of some old, wooden, one-story army-type buildings left over from World War II when Oklahoma University was a military base.

Colin: *So would you be in your studio on Sunday and hear forty thousand fans going bananas above you?*

Andrew: The art studio was located in another building. I don't remember hearing crowds, I was too busy trying to control the art materials that I was using.

Colin: *Were you influenced by pop art at that time? Did you see yourself as a future pop artist?*

A folding table

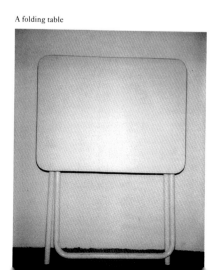

Blue Canoe
1988, oil on linen
mounted on wood
48 x 36 inches

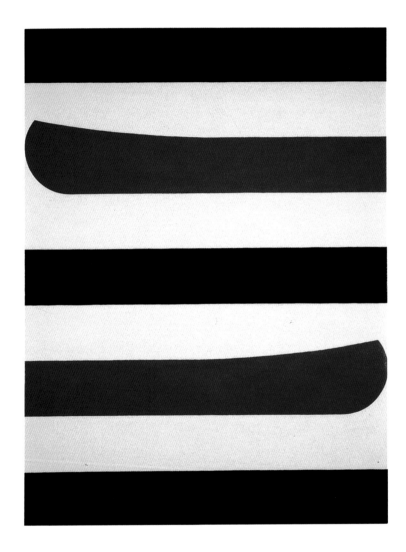

Chair
1984, oil on canvas
84 1/4 x 60 inches

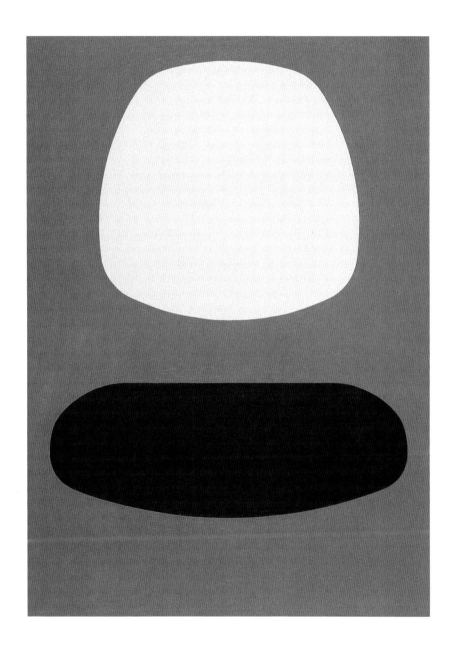

Crosswalks
1990, oil on linen
84 x 60 inches

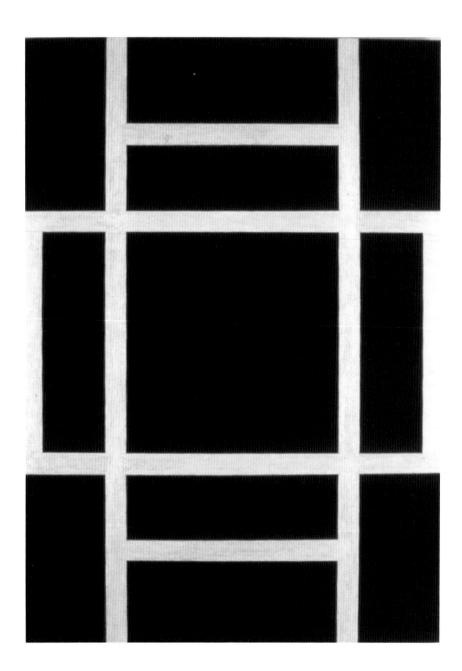

Andrew: I was just learning about pop art. I never really thought about being a pop artist.

Colin: *Eventually you made it out to California.*

Andrew: After two years at Oklahoma University I decided it was time for a change of scenery if I wanted to pursue painting seriously. I applied to Tyler School of Art in Philadelphia and spent my junior year attending their program overseas in Rome. After my senior year, I graduated from Tyler and headed out to the University of California, Santa Barbara for graduate school. I was a teaching assistant in the art department there and they gave me a forty-foot trailer as a studio.

Initially, California was like paradise. The climate was mild and sunny all the time. Fresh fruit, vegetables, and flowers grew all year round. The freeways had ocean views and were wide and smooth. Even the air was clean and clear in those days. At dusk people would parade out to the bluffs overlooking the ocean to watch the sunset. To me this was amazing—I had never seen anybody do this before. The sunsets really were spectacular.

After the University of California, Santa Barbara I moved to Los Angeles, got a job, and ended up staying for several years. Los Angeles is where I entered the art world.

Colin: *I think that one funny thing about your paintings is that your ideas started to come to you in Los Angeles. I do feel that your work is very personal. There are not ten other people working in your style.*

Andrew: Everything in Los Angeles seemed like it was new. There wasn't any sense of history. For me, it was a good place to try out new ideas and to experiment. Most of the people that I knew came from other places like

Los Angeles, 1975

Madrid, 1988

Stairwell
1987, oil on linen
mounted on wood
84 x 48 inches

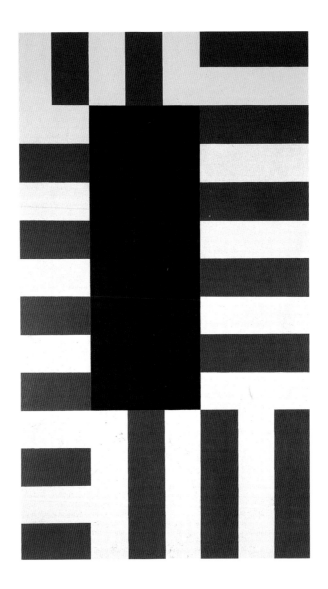

Nebraska, Arizona, or Mexico. Other than Sique and Nick Wilder, I don't remember meeting anyone else from the East Coast. I think that growing up in the East affected my outlook on California.

Colin: *There was a time when Nick Wilder started painting seriously after he quit art dealing. His paintings were geometric abstractions. How did you feel about this since you had this special relationship with him that basically covered your entire life as an artist?*

Andrew: Early on I realized that we were each pursuing totally different ideas in painting. The fact that we both chose a geometric format was coincidental. It was my understanding that Nick actually painted in a geometric style before he was an art dealer.

I think that our friendship intensified because of our common interest in geometric abstraction. We were secure enough in our own work to avoid feeling threatened by one another. We could share things like ideas or technical problems openly. To have had a rapport like that with another artist was very special to me and I one that will always remember. •

New York, 1991

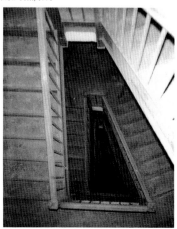

Segovia, 1988

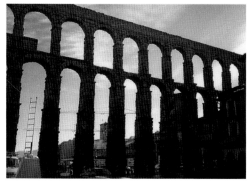

Picnic Table
1990, oil on linen
108 x 48 inches

Aquaduct
1989, oil on linen
mounted on wood
84 x 60 inches

Hanging Table
1990, oil on linen
72 x 48 inches

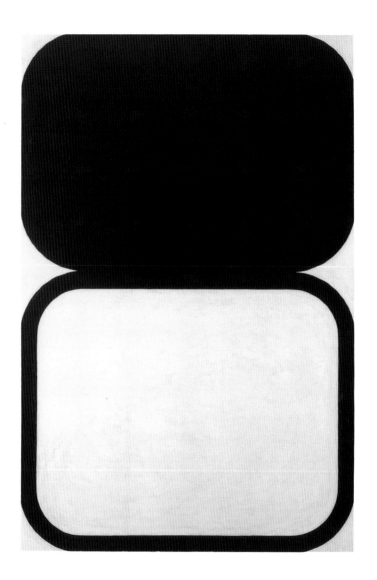

Chronology

1947
Born in Bryn Mawr, Pennsylvania.

1965
Attends a contemporary art exhibit for the first time at the Philadelphia Museum of Art.

1966-67
Studies art at the University of Oklahoma in Norman.

1968
Studies art at Tyler School of Art in Rome, Italy.

1969
Completes undergraduate studies at Tyler School of Art in Philadelphia. Enters the graduate painting program at the University of California, Santa Barbara.

1970
Meets Esther McCoy, an architectural historian, who later becomes a close friend and mentor.

1971
Completes graduate program at U.C.S.B. in painting. Moves to Los Angeles at Esther's urging. Works in art warehouse and rents studio space on Los Feliz Boulevard.

1972
Meets Nick Wilder, an art dealer who has storage at the warehouse. Sees several paintings by John McLaughlin in Nick's storage, which later become referential.

1974
Has first solo exhibition at the Nicholas Wilder Gallery in Los Angeles.

1975
Starts looking at mobile homes and industrial parks for art ideas.

1977
While on truck duty at the warehouse, packs up an exhibition at the art gallery of the University of California, Los Angeles titled "Connections: The World of Charles and Ray Eames," which also becomes referential. Marries Sique, moves to New York City.

1978
Begins to abstract images from everyday objects.

1982
Has first solo exhibition in New York at Barbara Toll Fine Arts.

1985
Re-establishes friendship with Nick Wilder, who has moved to New York and is also painting.

1987
Begins print projects: monotypes at Tullis Workshop in Santa Barbara and etchings at Parasol Press in New York. Receives a N.E.A. fellowship in painting.

1988
Travels to Spain with Sique, Nick Wilder, and Craig Cook.

1991
Continues to live and work in New York City.

Sketches for *Ivy Windows*

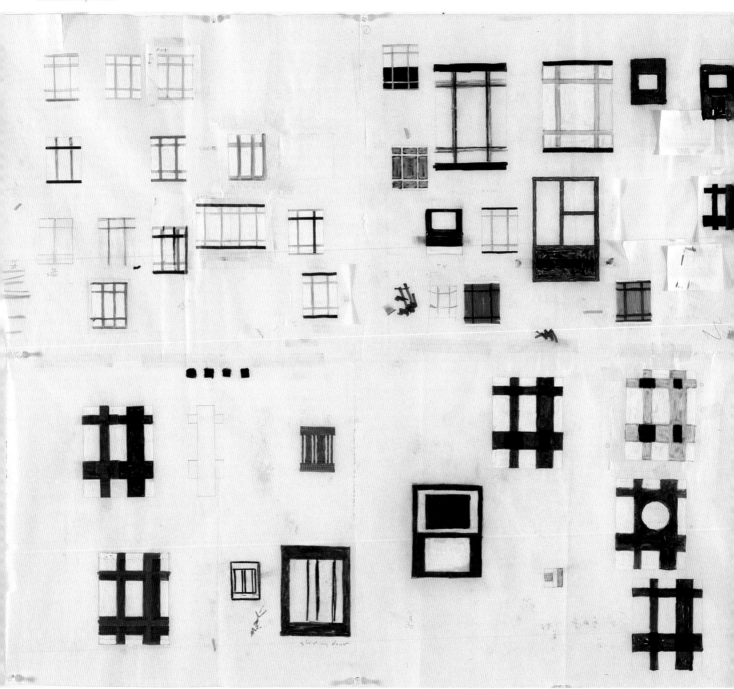

Ivy Windows
1988, oil on canvas
mounted on wood
75 x 60 inches

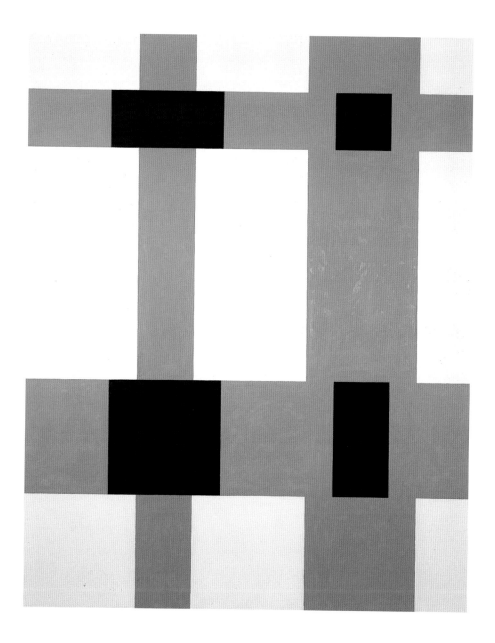

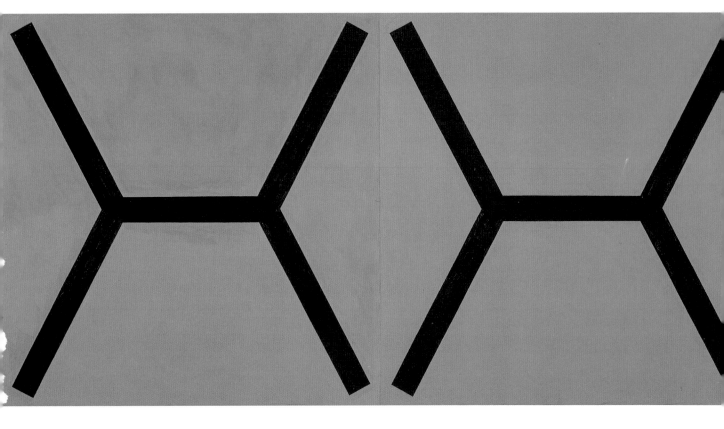

Tandem Painting
1991, oil on linen [5 parts]
40 x 200 inches

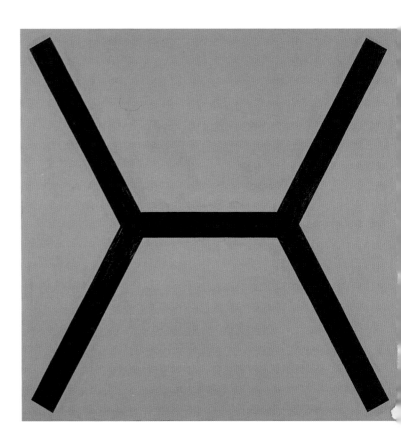

Red Corner Post
1987, oil on linen
mounted on wood
40 x 24 inches

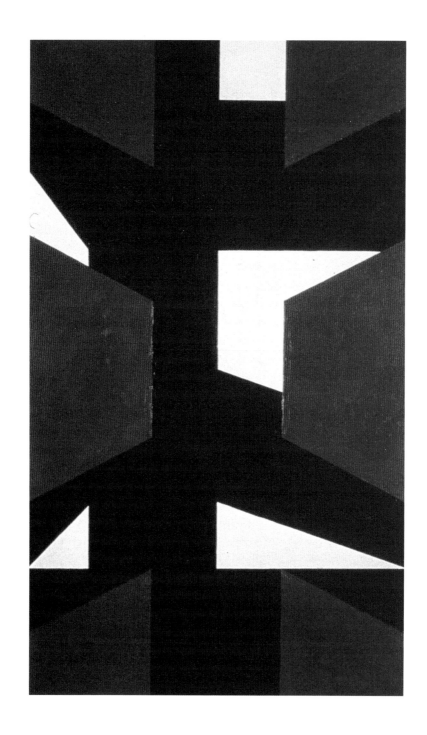

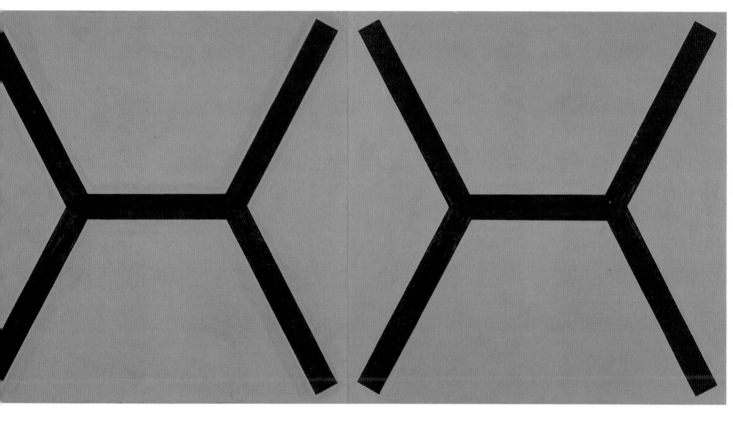

Andrew Spence

Andrew Spence's turn to externally derived images around 1975 marked the beginning of a body of work that he pursues today. After early years as a process-oriented painter, Spence adopted techniques that allowed him to join surface and pigment in shallow, architecturally referenced bas-reliefs. This fusion of eccentric—some might say Californian—color with a rationalist structure is typical of all of Spence's subsequent paintings. Abstract yet increasingly more literal, they constitute a sustained attempt at bridging nonobjectivity with graphic legibility. In both iconography and technique, Spence actively hybridizes a personal vision with an impersonal, universal standard.

The untitled paintings that occupied Spence after 1974 refer to shapes and a palette he developed while living in Los Angeles. A Philadelphia native, he had grown up in an urban environment radically different from the openness and light characteristic of Southern California: the city of Los Angeles sprawling out between the dusty greens and ochre of the desert, and the blues of sunny skies and the Pacific ocean. His paintings on molded acrylic adhered to canvas evoke the shallow relief of prefabricated building components—the decidedly populist design of mobile homes, with their unabashedly artificial configurations and colorations, were especially rich sources for him. This new universe of interchangeable parts symbolized the urbanization of postwar L.A., with its contingent of influential architects and designers—Ray and Charles Eames foremost among them.

Spence's move to New York in 1977 deprived him of daily contact with the visual stimuli of Southern California. New York's vertical and horizontal geometry quickened his literalist tendencies, and he began an extended suite of drawings that combined simple geometric shapes. Spence's longtime interest in design facilitated his recognition of the schema of various utilitarian objects in these newly regularized drawings. By contrast, the new works on canvas made in New York consisted of resolutely abstract imagery. In such paintings as *110* (1980) geometric forms act as subject. Besides his continually evolving experimentation as a colorist, Spence's principal concerns in them were formal. Characterized by layered, geometric and quasi-biomorphic imagery, the paintings speak of their indebtedness to John McLaughlin. By 1981, paintings of the faintly recognizable

Eames multiple seating

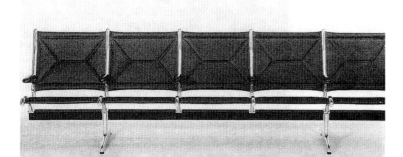

objects dominant in the drawings of the previous four years had begun. To underscore their origins in observed reality, Spence gradually began to assign them titles.

Rendered in oil, Spence's paintings are enlarged adaptations of his drawings, their taut edges rendered freehand. Always interested in evocative surfaces, he sands areas of color to minimize any distracting *pentimento*. Each painting thus gains a uniform opacity that helps dispel any intolerable, jarring spatial effect. The result elevates visual legibility above tactility: we are meant to read the painting as a whole. They are intended as abstractions that infer physical realities without depicting them. Spatial illusions are subordinated to this holistic, almost instantaneous legibility—first evident in the two-tone abstractions of the early 1970s. Only rarely, as in *Stairwell* (1987), does Spence complicate the pictorial illusion beyond simple image-ground relationships. The interlocking, faceted planes of that painting (and its related monotypes) are composed and colored to induce a deep, nearly vertiginous space analogous to the experience of looking down an open stairwell. Related overhead views are also the vantage point for paintings otherwise as disparate as *Swivel Chairs* (1988) and *Crosswalks* (1990).

The device of enlargement, favored by such twentieth-century abstractionists as Ellsworth Kelly, animates many of Spence's paintings. The scale of image to surface is especially critical in his composition, as he often prefers to crowd the canvas. By repeating motifs in elevation, such as those of *Blue Canoe* and *Aqueduct* (both 1988), Spence establishes an especially active negative-positive optical ratio. The difficult-to-decipher vantage point implied by *Picnic Table* (1990), in which a trestle bottom splays improbably to support a slotted top, is typical of other recent paintings. Although his treatment of the image in space varies from one group of paintings to another, Spence consistently preserves the integrity of his sources. Indeed, his work gains legitimacy from its candor.

Spence argues for a nonobjective painting that is abstracted from something in the outer world. His evolution as an abstractionist has been a lengthy one and his guiding principle has been to find and interpret simplified forms—often functional icons of modernity—in such a way that they oscillate between the specific and a universally legible symbol. His rational yet symbolic reinterpretation of nonobjective painting augurs well for the future of abstraction, that currently beleaguered offspring of the twentieth century.

Richard Armstrong
New York City
August, 1991

Public and Corporate Collections

Atlantic Richfield Company
The Baltimore Museum of Art
Chase Manhattan Bank, N.A.
Chemical Bank
The Cleveland Museum of Art
Estée Lauder Inc.
Exxon Corporation
Fried, Frank, Harris, Shriver, and Jacobson
Hirshhorn Museum and Sculpture Garden, Smithsonian Institute
IBM Corporation
IT&T Corporation
La Jolla Museum of Contemporary Art
Laguna Gloria Art Museum
Metropolitan Museum of Art
Museum of Modern Art
Orlando Museum of Art
Progressive Corporation
Prudential Insurance
Reader's Digest Collection
Santa Barbara City College Collection
Shearson-Lehman/ American Express
The Sumitomo Bank of California
Walker Art Center
Whitney Museum of American Art

Selected Reviews and Articles

1990
Myers, Terry. Review, *Arts Magazine,* September.
Tonkinson, Carole. Review, *Elle,* March, p. 214.

1989
Cotter, Holland. "Report from New York," *Art in America,* September, pp. 81-87.
Grimes, Nancy. "Whitney Biennial," *Tema Celeste,* September, pp. 66-68.
Heartney, Eleanor. Review, *Art in America,* February, p. 162.
Hornung, David. Review, *Artnews,* January, p. 134.
Decter, Joshua. Review. *Arts,* January, p. 103.
Perl, Jed. "Keeping the Faith," *The New Criterion,* June, p. 46.
Perl, Jed. "The Old is New," *Vogue,* August, pp. 214-218.
Smith, Roberta. "More Women and Unknowns in the Whitney Biennial," *The New York Times,* April 28, p. C32.
Stapen, Nancy. "Neo-Geo Spence Paints a Lasting Impression," *The Boston Herald,* April 4, p. 34.
Wilson, William. "Deja Vu-ing at the Whitney," *The Los Angeles Times,* April 29.

1988
Klein, Ellen Lee. Review, *Arts Magazine,* April, p. 109.

1987
Brenson, Michael. "Art View: True Believers Who Keep the Flame of Painting," *The New York Times,* Sunday, June 7.
Loughery, John. "Affirming Abstraction: The Corcoran Biennial," *Arts Magazine,* September, p. 76-78.
Richards, Paul. "Painting in Past Tints: At the Corcoran's Biennial, Contemporary New York Artists," *The Washington Post,* Saturday, April 7.
Smith, Roberta. "Art: Generations of Geometry, an Abstract Show," *The New York Times,* Friday, July 17.
Thorson, Alice. "Two Ways of Approaching Abstraction," *The Washington Times,* Thursday, May 14.

1986
Lurie, David. Review, *Arts Magazine,* January, pp. 137-138.

1984
Westfall, Stephen. Review, *Art in America,* January, p. 124.

1983
Armstrong, Richard. Review, *Artforum,* December, p. 83 (illus.).

1977
App, Timothy. "Six Approaches to Formalist Abstraction," *Artweek,* March 5, p. 7.
Muchnic, Suzanne. "Four Abstractionists—Krebs, Spence, Therrien, Geogesco," *Artweek,* May 26.

1976
Rush, David. "Andrew Spence: Avoiding Gravity Plays," *Artweek,* September 25, p. 7.
Wilson, William. "Artwalk/A Critical Guide to the Galleries," *Los Angeles Times,* Friday, April 9, Part IV, p. 12.

1974
Wilson, William. "Artwalk/A Critical Guide to the Galleries," *Los Angeles Times,* Friday, April 26, Part IV, p. 14.

Collaborations

1990
Aquatints published by Parasol Press, New York. Woodcuts published by Spring Street Workshop, New York.

1989
Aquatints published by Parasol Press, New York. Monotypes published by Garner Tullis Workshop, Santa Barbara, California.

1988
Cover art for *Paris Review,* Fall issue.

1987
Monotypes published by Garner Tullis Workshop, Santa Barbara, California.

Selected Solo Exhibitions

1991
"Insights: Ann Messner and Andrew Spence"
Wooster Art Museum
Wooster, Massachusetts

1990
James Corcoran Gallery
Los Angeles, California

Compass Rose Gallery
Chicago, Illinois

Barbara Toll Fine Arts
New York, New York

1989
Barbara Krakow Gallery
Boston, Massachusetts

1988
"Monotypes"
Barbara Toll Fine Arts
New York, New York

"New Paintings"
Barbara Toll Fine Arts
New York, New York

1987
Barbara Toll Fine Arts
New York, New York

1985
Barbara Toll Fine Arts
New York, New York

1983
Barbara Toll Fine Arts
New York, New York

1982
Barbara Toll Fine Arts
New York, New York

1976
Charles Casat Gallery
La Jolla, California

Nicholas Wilder Gallery
Los Angeles, California

1974
Nicholas Wilder Gallery
Los Angeles, California

Selected Group Exhibitions

1991
"The 1980s: Selections from the Permanent Collection"
Whitney Museum of American Art
New York, New York

"Art on Paper"
Weatherspoon Art Gallery
Greensboro, North Carolina

1990
"Real Allegories"
Lisson Gallery
London, England

1989
"Whitney Biennial"
Whitney Museum of American Art
New York, New York

"New Acquisitions"
Hirshhorn Museum and Sculpture Garden
Smithsonian Institution
Washington, D.C.

1988
"Collaborations in Monotype"(travelled)
University Art Museum
University of California
Santa Barbara, California

1987
"The Fortieth Biennial Exhibition of Contemporary American Painting"
Corcoran Gallery of Art
Washington, D.C.

"Five Abstract Artists"
Robert Storr, curator
New York Studio School
New York, New York

"Generations of Geometry"
Whitney Museum of American Art
at the Equitable Center
New York, New York

1986
"New Visions in Contemporary Art: The RSM Company Collection"
Cincinnati Art Museum
Cincinnati, Ohio

1984
"Current 6: New Abstraction"
Milwaukee Art Museum
Milwaukee, Wisconsin

1983
"Viewpoints: Out of Square"
Cranbrook Art Museum
Bloomfield Hills, Michigan

1982
"Nine Critical Perspectives"
The Institute for Contemporary Art
P.S. 1, Long Island City, New York

"Painting and Sculpture Today 1982"
Indianapolis Museum of Art
Indianapolis, Indiana

"RSM: Selections from a Contemporary Collection"
Herron Gallery
Herron School of Art
Indianapolis, Indiana

1980
"Geometric Abstraction"
Proctor Art Center at Bard College
Annandale-on-Hudson, New York

1978
"100+ Current Directions in Southern California Art II"
Los Angeles Institute of Contemporary Art
Los Angeles, California

1977
"Four Californians"
La Jolla Museum of Contemporary Art
La Jolla, California

"Abstract Painting"
Fine Art Gallery at Long Beach City College
Long Beach, California

1975
"Whitney Biennial"
Whitney Museum of American Art
New York, New York

1974
"24 from Los Angeles"
Municipal Art Gallery
Los Angeles, California

1971
"Spray"
Santa Barbara Museum of Art, Santa Barbara, California

5/95